Just when you thought it was safe for your maiden aunt to look at the walls again, they're alive with yet more sharp, scatty and sexy comments on the human condition. After **Graffiti Lives, OK** and **Graffiti 2** there is a Third Coming with **Graffiti 3**, a galaxy of over 400 graffiti, as old as the hills or as topical as today's headlines.

Nigel Rees, of whom it has been said that he is doing for graffiti what Bolognese sauce has already done for spaghetti, brings together an entirely new collection of the funniest and wittiest scribblings and 'scratchings' designed to amuse and entertain graffiti writers and graffiti spotters alike. There is also everything you will ever need to know about those legendary graffiti names – Kilroy, Chad and J B King, plus a special section of 'Resprays' – reworkings of some of the highlights from **Graffiti Lives, OK** and **Graffiti 2**.

Also by Nigel Rees in
Unwin Paperbacks
'Quote…Unquote'
(also available in hardback)
Graffiti Lives, OK
Graffiti 2
Very Interesting…But Stupid!
Published in hardback by
George Allen & Unwin
The 'Quote…Unquote' Book
of
Love, Death and the Universe

GRAFFITI 3

NIGEL REES

London
UNWIN PAPERBACKS
Boston Sydney

First published in Unwin Paperbacks
1981

UNWIN® PAPERBACKS
40 Museum Street, London WC1A 1LU

This edition
© Nigel Rees Productions Ltd, 1981

British Library Cataloguing in Publication Data

Rees, Nigel
 Graffiti 3.
 1. Graffiti
 I. Title
 828'.02 GT3912

 ISBN 0-04-827030-X Pbk

Art Director David Pocknell
Design: David Pocknell's Company
Limited
Cover: Tony McSweeney
Typeset in Times New Roman

Made and printed in Great Britain
by the Anchor Press Ltd, Tiptree, Essex

Beware of bathroom walls.
That've not been written on.

> *Bob Dylan,*
> *'Advice for*
> *Geraldine on her*
> *Miscellaneous*
> *Birthday'*

Really the writer doesn't want
success…He knows he has a
short span of life, that the day
will come when he must pass
through the wall of oblivion, and
he wants to leave a scratch on
that wall – Kilroy was here – that
somebody a hundred, or a
thousand years later will see.

> *William Faulkner*

The words of the prophet are
Written on the subway halls
And tenement walls.

> *Paul Simon,*
> *'Sound of Silence'*

There's many an airman has
blighted his life.
Thro' writing rude words on the
wall.

> *Jimmy Hughes*
> *and Frank Lake,*
> *'Bless 'em all'*

The subject of graffiti, like the human functions that give rise to so many of them, is a great leveller. The popularity of **Graffiti Lives, OK** and **Graffiti 2** has brought me into contact with a wonderful range of people who, if nothing else, have in common the fact that they derive great delight from contemplating the writings on the wall. Some have suggested that what we have here is a sub-culture – but graffiti-writing is so prevalent it has almost become a culture in its own right. Of course, it glances off to refer to other cultures – quotations, slogans, straightforward jokes. But there are some graffiti that could exist in no other form, and the peculiar, anonymous nature of their creation and dissemination is unique. This, to my mind, is the only sense in which graffiti are a kind of 'underground' humour or folk culture.

In this third selection, although most of the graffiti come from the United Kingdom, I hope it will be apparent that graffiti-culture is truly international. Wherever English is spoken the same jokes and slogans may recur, but there is a spirit to graffiti-writing which cuts across language and cultural barriers.

My previous two little books have travelled far and I have been delighted at the response and reaction I have received from distant parts. Most pleasing of all was to have **Graffiti 2** subjected to review by Richard Hughes in the Hong Kong-based **Far Eastern Economic Review.** Readers of John Le Carré's novel **The Honourable Schoolboy** will know of this formidable, almost legendary journalist. For reasons best known to himself, Mr Hughes refers to me throughout his review as 'Dr' Rees (thinking of some Department of Mural Philosophy perhaps), an honour my light-hearted excursions into graffiti territory scarcely warrant. Mr Hughes is much more in need of commendation than I for his comparative studies in this subject. Describing

himself as 'a senile Aussie', he says he has
discovered in 'evangelical travel over the years in
China, Japan, Korea and South-East Asia, that
graffiti are again among the areas where the East
and West *do* meet…the 1973 Chinese scrawlings
were still less parochially political than universally
censorable in the public conveniences on the Great
Wall'.

Urging me to take a trip to China to
persuade the Peking Politburo that revised
anonymous graffiti rather than officially inspired
wall-writings could be another human step towards
modernisation, Mr Hughes then pulls out of his
memory-bag a really wonderful fact, worthy of
recording in the **Guinness Book of Records.** The
longest wall inscription in history, he says, was
written by Chairman Mao himself, when a 22-year-
old student, on the walls of a boy's lavatory (called
with wonderful euphemism 'Men's Pavilion') at his
old school in Changsa in June 1915.

According to a report in the Chinese army
magazine **Chieh Fang** (December 1968), Mao's
graffito ran to a total of 4,000 characters in an attack
on his No. 1 teacher, Chang Kan. The handwritten
proclamation exposed the crimes of the head
teacher and severely criticised the entire feudalistic
system of the dark old world. Chang Kan 'trembled
in fear when he read the message, which was
supported by 1,000 progressive students, and the
all-powerful revisionist was pulled down from his
throne *[sic]*'.

Graffiti-power! How appropriate that this
supreme example should come from the country
with the most illustrious wall-space in the universe.
Still, I do not suppose it contained many jokes.

Richard Hughes also had some comments
to make about my simple generalisations (in the
introduction to **Graffiti 2**) about the difference in
frequency and subject-matter between men's and

women's graffiti, but draws a slightly wrong
inference from my suggestion that women's graffiti
in the 1980s is even more preoccupied with sex. He
recalls Sir Harold Winthrop Clapp, no less,
chairman of Australia's Victorian Railways in the
days when Hughes worked for them, **circa** 1930.
Clapp apparently once silenced an irritating
delegation of 'unruly chauvinistic sows', who were
demanding velvet seats in railway dunnies, by
pointing out that 'the worst graffiti written on
railway station conveniences are perpetrated by
women and not men'. Hughes comments, 'Some of
the women looked guilty. Sir Harold always knew
his facts'.

A number of women correspondents, too,
have fallen on my remarks, so perhaps they need a
little development. As with all aspects of graffiti
there is very little hard evidence to go on, but the
general assumption would seem to be this: when
Kinsey looked into the subject in the United States
(1948-53) his conclusion was that relatively few
females made wall inscriptions and, when they did,
fewer of the inscriptions were erotic (25 per cent
compared with 86 per cent for men). By 1975
another team of American researchers was still
finding fewer erotic inscriptions by women, but the
proportion had doubled to 50 per cent. They made
no comment on the overall number of graffiti
written by women.

Something they did find, however, was that
the percentage of homosexual graffiti made by both
sexes had decreased. Almost certainly this must
have had something to do with the greater public
visibility of homosexual rights groups and a more
open approach to the whole subject.

On the other hand, the Women's
Movement of the 1970s, far from coming out of the
closet, has, in a sense, retreated into it. So much so
that the volume of women's graffiti is now probably

equal to that of men's. Whether it is as *funny* is another matter. The feminist movement has used the lavatory wall as a *serious* vehicle for the expression of its views.

My remark in **Graffiti 2** that graffiti are frequently alcohol-induced, which may lead to more maudlin comments from women and more effervescent ones from men, is something that could be debated for as long as there are hedgehogs in Hampstead. But a number of feminist correspondents have taken me to task for ignoring what they see as the prime reason for a lack of humour in women's graffiti: namely, that the lot of women is still not a happy one and that they don't find their lives that much fun. Hence, less amusing graffiti and an apparent preoccupation with erotic matters. Not for them the wide range of men's graffiti – football, politics, and simple jokes.

Among theories applying to graffiti-writers of both sexes that have been suggested to me are: that such people are 'non-rugged individualists' because they make their point without much fear of any comeback; that they are like the space scientists who send out probes filled with souvenirs and artefacts depicting human culture, saying in effect 'I am here, I exist'; that they are 'lone snipers' using words instead of bullets; that they are marking out their territory, fortunately not using the canine method of doing so.

However, the 'marking out of territory' and 'I am here, I exist' reasons for graffiti-writing probably apply more to the writing of names and initials than to the more imaginative graffiti with which these books are concerned. The former type of graffiti is particularly prevalent in New York, where the writing of signatures or 'tags' in colourful ways, mostly on subway trains, has reached epidemic proportions and costs the transit authority *$6.5 million a year* to remove.

Yet again I would stress that I have no truck with that sort of thing. I enjoy the witty expression of ideas through graffiti but regret the relatively minor vandalism they involve. If after reading the following four hundred or so graffiti, ranging from the venerably old to the sharply topical, you feel inclined to avoid the whole phenomenon, go to Finland. A correspondent reports that in three weeks touring that country he only saw one graffito, incorrectly lettered and in all probability by a tourist, the words:

LED ZEPPLIN.

Mindful of a graffito I encountered in the rather more bedaubed surroundings of Wolsey's Wine Bar in London W1, I will now bring my remarks to a close. It said, simply:

NIGEL REES TALKS A LOAD OF OLD WALLS

Nigel Rees

"Goodness knows I've tried, Deborah, but somehow I can never think of the one graffito that every vandal's supposed to have inside him."

RED ARROWS FLYING
DISPLAY
– if wet, in Town Hall.
Fowey

Why is it that the only people
who know how to run our country
are either driving cabs or cutting
hair?
Vancouver, B.C.

This film contains scenes of
explicit sexual interhorse.
on Equus *poster,*
London

ALL THE BIG
WOMEN DIG YOUNG
THATS WHY WE'RE
LEFT WITH LITTLE
OLD LADIES.
Paris

Give peace a aah-argh!
Covent Garden

My heart aches and a drowsy
numbness drains my sense as
though of hemlock I had drunk.
Signed: a British Rail tea victim.

*King's Cross
station, London*

THE ECONOMY IS THE
SECRET POLICE OF OUR
DESIRES

Swiss Cottage

THE IRISH ARE BASTARDS

yes they've got English fathers

Eastbourne

*I*s a tramp without legs a low
down bum?

Worksop

*I*ci s'écroulent en ruines
Les triomphes de la cuisine.

*written in the
outside loo of the
composer
Constant Lambert*

*T*HIS IS THE AGE OF THE
TRAIN
– ours was 104.

*Paddington
Station, London*

*K*EEP AUSTRALIA GREEN
– have sex with a frog.

Sydney

I'm oxymc

When I

*T*he young man who was asked by Joyce McKinney to marry her replied that he was too young to be tied down.

London W1

*D*ada wouldn't buy me a Bauhaus.

Norwich

*P*ARIS EVERY SPRING
JEANS EVERY WEEKEND
DAILY MAIL EVERY DAY
– Valium every night.

London WC1

*L*ENNY IS A STUPID FAGET
– I may be stupid but at least I can spell fagget.

New York

voniC even
m not.

Lymington

*T*his door will shortly be
broadcast on Radio 4.

on door of ladies'
lavatory,
Newcastle-upon-
Tyne

O.H.M.S. —
INTEREST
ECON
PLEASE USE
SIDES OF

*N*othing succeeds like a parrot.
Worksop

IN THE

OF WAR

OMY

BOTH

THE PAPER

gents' lavatory
Whitehall, Second
World War

Doctor: I am afraid you are
suffering from Alice.
Patient: What's that?
Doctor: We don't really know, but
Christopher Robin went down
with it.

*Leeds Hospital
Medical School*

VIOLEZ VOTRE ALMA
MATER.

Nanterre, 1968

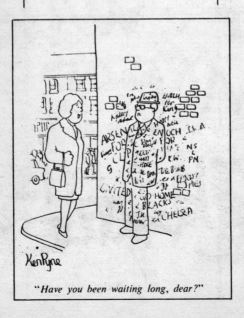

"Have you been waiting long, dear?"

Sock it to me with apathy.
> *Boston, Mass.,*
> *1969*

Aphorism is the death-rattle of the Revolution.
> *Balliol College,*
> *Oxford, 1968-9*

Rizla Skins Roll OK.
> *University of*
> *Leeds*

IF GOD EXISTS THAT'S HIS PROBLEM

> *Edinburgh*

HOMES TO SEM

At this moment you are the only man in the army who knows what he's doing.

gents' lavatory,
Aldershot

FoUow the Little Arrows

instruction in
gents' lavatory,
Taunton. The
arrows went up
the wall and
along the ceiling,
where was
written:

R RETIRED
EN

*on contraceptive
vending machine,
Piccadilly,
London*

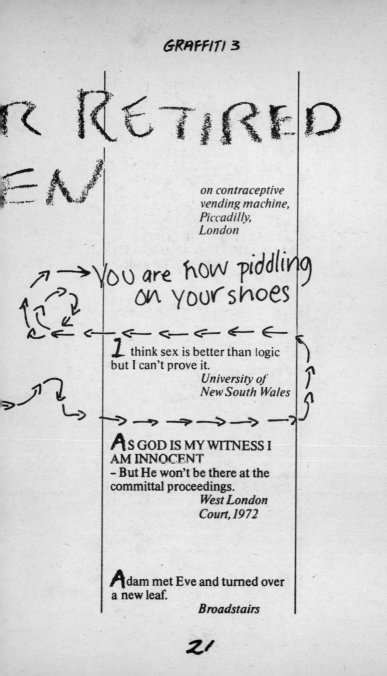

You are now piddling
on your shoes

1 think sex is better than logic
but I can't prove it.
*University of
New South Wales*

AS GOD IS MY WITNESS I
AM INNOCENT
– But He won't be there at the
committal proceedings.
*West London
Court, 1972*

Adam met Eve and turned over
a new leaf.
Broadstairs

*I*N CASE OF ATOMIC
ATTACK:
1. PUT YOUR HANDS OVER
YOUR EARS.
2. PUT YOUR HEAD
BETWEEN YOUR LEGS.
3. KISS YOUR ASS GOODBYE.
San Francisco

*I*N SIX DAYS THE LORD
MADE HEAVEN AND EARTH,
THE SEA, AND ALL THAT IN
THEM IS
– he was self-employed.
Maldon

*A*VE MARIA
– I don't mind if I do.
Nottingham

*B*ALLS TO BALLS
Cambridge

*R*epeal the Banana.
Melbourne

*T*heda Bara is a form of Arab
Death.

Chicago

*T*he BBC has always been 50
years old.

*during
anniversary
celebrations, 1972*

*D*on't complain about the beer.
You'll be old and weak yourself
one day.

Oxford pub

*J*oe Jordan kicks the parts other
beers don't reach.

Northolt

*D*o you think that because of the
element of uncertainty introduced
into quantum theory by wave
mechanics that there will be an
ultimate limit to human
knowledge? Courtesy of
Sophisticated Graffiti Inc.

Moffat, Scotland

Why not buy 144 and be grossly oversexed?

on contraceptive vending machine, Blackpool

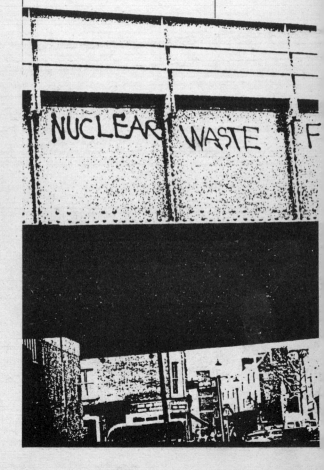

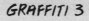

> **W**ARNING. BERLIN POLE
> VAULTERS' TRAINING
> GROUND
> *on Berlin Wall*

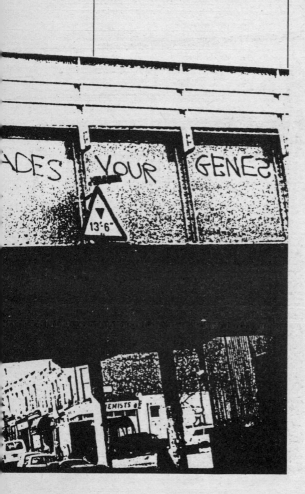

*H*ere's to the cut that never heals, The longer you stroke it, the softer it feels.
You can wash it in soap, you can wash it in soda,
But nothing removes the Billingsgate odour.

during Second World War, West Midlands

*B*RING BACK THE BIRCH
– please!

London NW1

*B*LACK POWER
– is it cheaper than gas?

Brixton

*J*ust gone for a walk round the block. Anne Boleyn.

Hull

*S*ee the Atomic Blonde!!
Blasted into maternity by a guided muscle!!

London W1

WITH BOOZE
YOU LOSE
WITH DOPE
YOU HOPE
BLOW YOUR MIND —
SMOKE GUNPOWDER

Harwich

Jesus jogs.

*Camperdown,
N.S.W.*

Persuasion rules OK –
just this once!

Brighton

If I said you had a nice body,
would you hold it against me?
Worksop

STAN BOWLES HAS LAID ON MORE BALLS THAN FIONA RICHMOND

Fulham

If you don't vote for me, I'll hold
my breath.

*on Shirley Temple
Black election
poster, 1960s*

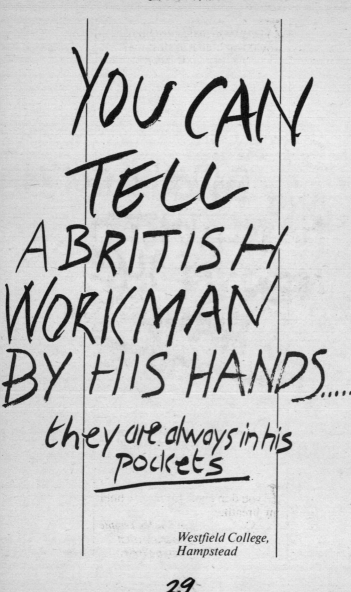

YOU CAN TELL A BRITISH WORKMAN BY HIS HANDS.....

they are always in his _pockets_

Westfield College,
Hampstead

*B*URGERS IN BERKSHIRE
WINE IN WILTSHIRE
COFFEE IN CORNWALL
British Rail
catering poster,
to which had
been added:
– Sick in Southend.

ONE IN KATE BUSH IS WORTH TEN IN THE HAND

Bristol

*D*o not bend, fold, staple or
mutilate in any way this wall.
Wisconsin

*C*ambridge, give me back my
mind.
Cambridge

The sexual urge of the Camel
Is greater than anyone thinks.
After several months on the
desert,
It attempted a rape on the
Sphinx.
Now, the intimate parts of that
Lady
Are sunk 'neath the sands of the
Nile.
Hence the hump on the back of
the Camel
And the Sphinx's inscrutable
smile.

artillery camp,
Cairo, 1940

THICK CARROT SOUP IS
BEST

Lambeth Bridge

Worksop

EARN CASH IN YOUR
SPARE TIME
– blackmail your friends.

Manhattan

No to M
Racia|S
Send th
back S

ROCK AGAINST RACISM
– Nihilists against everything.
Eastbourne

ulti-

ciety

Angles

gned

A. Celt

Brent Cross

More people died at
Chappaquiddick than at Three
Mile Island.

New York, 1980

KILROYW

In *Graffiti Lives, OK,* I mentioned what to me seems the most likely of the various explanations put forward for the origin of the phrase 'Kilroy was here'. Eric Partridge in his *Dictionary of Slang and Unconventional English* quotes a clipping from the *San Francisco Chronicle* of 2 December 1962: 'Two days before the Japanese attack on Pearl Harbour, an unimposing, bespectacled, 39-year-old man took a job with a Bethlehem Steel Company shipyard in Quincy, Mass.

'As an inspector…James J. Kilroy began making his mark on equipment to show test gangs he had checked a job. The mark: "Kilroy was here".

'Soon the words caught on at the shipyard, and Kilroy began finding the slogan written all over the installation.

'Before long, the phrase spread far beyond the bounds of the yard, and Kilroy – coupled with the sketch of a man, or at least his nose peering over a wall – became one of the most famous names of World War II.

'When the war ended a nation-wide contest to discover the real Kilroy found him still employed at the shipyard.

'And last week, James Kilroy…died in Boston's Peter Bent hospital, at the age of 60'. Stuart Berg Flexner in *I Hear America Talking* states

confidently that the phrase had begun to appear in a few docks and ships and in large ports in late 1939 and was well established by 1942.

Partridge also offers a rival theory, quoting from another (1945) newspaper clipping:

'The phrase originated in the fact that a friend of Sgt Francis Kilroy thought him a wonderful guy and scrawled on the bulletin board of a Florida air base, "Kilroy will be here next week". The phrase took the fancy of army fliers and it spread across the world'.

There is no doubt in my mind that 'Kilroy' is of American origin. Quite what he stands for or stood for is another matter. William Safire in his *Political Dictionary* speaks of the name as a 'sobriquet for the American soldier who – in every battleground and staging area of World War II – "was here" '.

Bemoaning the decline of the sobriquet in political life, Safire wonders, 'Was Eugene McCarthy getting close to the national mood when he wrote a poem about the disappearance of "Kilroy"... [hinting] that the disappearance of "Kilroy" meant the disappearance of pride?'

Take your pick.

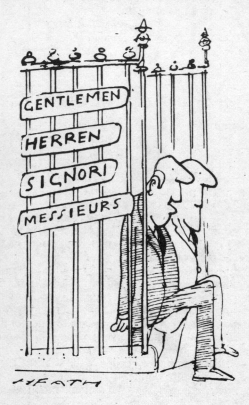

"*I suppose it makes a change to see all that foreign graffiti.*"

Masturbation is great – and you don't have to take your hand out to dinner afterwards and talk to it about its problems.

gents' lavatory,
London W1

BRING YOUR CHILDREN TO LONDON

British Rail
poster,
Manchester

– And leave the little buggers there.

GO TO CHURCH ON SUNDAY AND AVOID THE CHRIST-MAS RUSH

Horncastle

Cisterns of the world unite – you have nothing to lose but your chains.

Tunbridge Wells

Last Coke for 3,000 miles.
on Berlin Wall

JESUS LIVES
– does this mean we won't get
an Easter holiday then?
 Bristol

VOTE COMMUNIST
– Remember Hungary
– Remember Czechoslovakia
– Remember the spelling
– Tanks for the memory.
 Otley

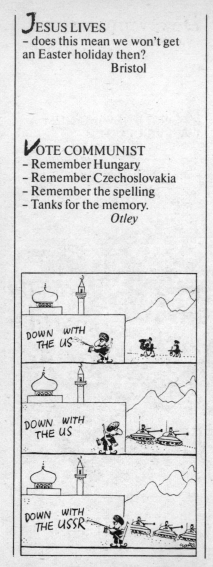

DOWN WITH PROTESTS
- up with graffiti.
New York

WORST CHEWING GUM
I'VE EVER TASTED
 on contraceptive
 vending machine
- Oh, but what bubbles!

CONFUCIUS HE SAY: WHLST CHAIN SWING, SEAT WILL BE WARM

Bath

41

*B*eware! Jacques Cousteau filming.

ladies' lavatory,
BBC

I don't think crazy paving is all it's cracked up to be.

Leighton Buzzard

*C*rime is the highest form of sensuality.

London W11

*W*as Danny La Rue the last woman to hang?

Worksop

*T*imothy Davey got six years for peddling shit.
Lew Grade got a knighthood for it.

Elstree

*T*he DC10 is not all its cracked up to be.

Gatwick Airport

42

MORE DEVIATION LESS POPULATION

Miami Beach

DISARM TODAY—
DAT ARM TOMORROW

Stafford

DIDDUMS WILL GET BOUNCED

Durham

Anti-social diseases are a sore point.

Birmingham

Beat inflation. Eat the Rich.

Sydney

OK sauce rules, HP

Hitchin

Q. Why is semen white and urine yellow?
A. So an Irishman can tell whether he's coming or going.

Fulham

You'll believe a woman can fly.

on Bedknobs and Broomsticks
poster

MORDEN
– enough.

*London
Underground
map*

We are the writing on your wall.
*at 144, Piccadilly
London, when
taken over by
squatters*

LITTLE RED RIDING HOOD IS A RUSSIAN CONTRACEPTIVE

*Museum station,
Sydney*

OH, VERY WITTY, VERY CLEVER ALL YOU GRAFFITI WRITERS, SOME REALLY GREAT MATERIAL, BUT HAVE YOU EVER STOPPED TO THINK WHO HAS TO CLEAN THIS MESS UP? NO, OF COURSE, YOU HAVEN'T BUT LET ME TELL YOU ITS VERY HARD WORK AND TAKES A HELL OF A LONG TIME. SIGNED: an Overworked Council Worker

written among
much other graffiti
on a wall in Bootle

*W*hat is the difference between God and Father Christmas? There is a Father Christmas.
Dublin

*T*HIS CISTERN IS FITTED WITH DOLBY
– takes the slush out of flush.
– takes the hiss out of piss.
Leeds

СВЕРХУ МОЛОТ
СНИЗУ СЕРП
ЭТО – НАШ
СОВЕТСКИЙ ГЕРБ
ХОЧЕШЬ – ЖНИ,
А ХОЧЕШЬ КУЙ,
ВСЁ РАВНО
ПОЛУЧИШЬ,
ХУЙ!

Rough translation
Below – the sickle
Above – the hammer:
This is the seal on our Soviet
banner.
Whatever in life
You choose to do,
It's all the same:
You'll still get screwed.
 Moscow, 1966

LIGHT EMBAS THE S

What's the difference between E.M.I. and the Titanic?
The Titanic had a better band.
London W1, 1979

How will I know if I'm enlightened?
London W11

All this graffiti is too heavy!
Why doesn't anyone write about bunny rabbits?
Sussex University

UP AN
SY -JOIN
.A.S.

*Liverpool Street
Station, London*

*E*skimos are God's frozen
people.

Greenwich

*F*UCK YOUR ETHNIC GROUP
- Yassuh!

New York

*E*ve was framed.
> *ladies' lavatory,*
> *Dublin*

*I*s euthanasia justified in the case of Dutch elm disease?
> *Cambridge*

*Y*es! Everything was so different before it all changed.
> *Newcastle-upon-*
> *Tyne*

*F*AITH CAN MOVE MOUNTAINS – she's a big girl.
> *Corsham*

*T*HE FAMILY THAT PRAYS TOGETHER STAYS TOGETHER – thank God my mother-in-law's an atheist.
> *Los Angeles*

*P*lumbers don't die, they just go down the drain.
> *Cromer, N.S.W.*

God give me patience – but hurry please!

London W1

W. C. Fields is alive and drunk in Philadelphia.

Philadelphia

Come home to a real fire – buy a cottage in Wales.

Swansea, 1980

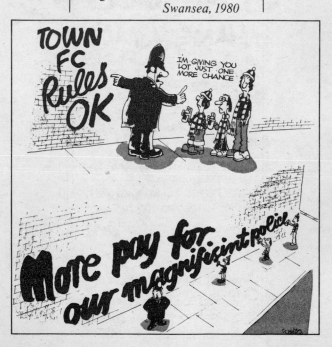

Fireraisers of the world ignite!
Hampstead

Who took the fizz out of physics?
Cambridge

fly the flag:
HANG A MOD!
Streatham

Flags today – gas masks tomorrow.

*Chelsea,
observed by Vera
Brittain at the
time of George V's
Silver Jubilee,
1935*

You can't fool all of the people all of the time, but if you do it just once it lasts for five years.
British Museum

*I*t is forbidden to forbid.
Paris, 1968

*F*ree persons everywhere.
Covent Garden

STAMP OUT VANDALISM OR I'LL BREAK YOUR WINDOWS

Sutton

Why not an actor? We've had a clown for four years.

New York, 1980

Q. WHATS THE DIFFERENCE BETWEEN AN EGG AND A WANK.
A. YOU CAN'T BEAT A WANK

Cardiff

GOD WILL PROVIDE
– only God knows if there is a God.
– God only knows if there is a God.

Birmingham

Equality is a myth. Women are better.

N.S.W. Institute of Technology

FREE WALES
– from the Welsh.

Newport, Dyfed

*I*f the French won't buy our lamb we won't use their letters.
> *on back of motorway juggernaut, during 'Lamb War,' 1980*

THERE IS NOTHING SO OVERRATED AS A BAD FUCK AND NOTHING SO UNDERRATED AS A GOOD SHIT.

> *Ottawa*

ANYWHERE, PROVIDING IT BE FORWARD
– The Gadarene Swine
> *church wayside pulpit*

*G*ASCOIGNE PEES

> *estate agents'*
> *notice-board,*
> *Woking*

– don't we all?

*I*s a lesbian a pansy without a
stalk?

> *Sheffield*

CITY
PLANNERS
DOIT WITH
THEIR
EYES
SHUT

> *Bath*

*T*here's no future in being gay.

> *Lincoln*

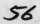

I am bi-sexual. If I can't get it I
buy it.

London W1

OLD GOLFERS NEVER DIE THEY SIMPLY LOSE THEIR BALLS.

Coventry

SHAKE HANDS WITH YOUR
BEST FRIEND
– Shake hands with the
unemployed.

*gents' lavatory,
Sydney*

The most common graffito of the past forty years, apart from 'Kilroy was here' (although it is sometimes found in conjunction with that phrase), is the so-called Chad – also known as 'Mr Chad' or 'The Chad'.

In Britain at least, it is generally accepted that Chad made his first appearance in the early stages of the Second World War, accompanied by comments or protests about shortages of the time such as

The questions one would dearly like to see answered are: How did Chad arise? Why does he have this particular form? And why is he called Chad? Looking for answers to these questions is fun, though a definitive explanation of the origin of Chad is about as likely as a definitive explanation of 'Kilroy was here'.

The matter is further complicated by the fact that in the United States the picture of Chad has often been accompanied by the phrase 'Kilroy was here' or

'WOT, NO KILROY?'

In the U.K., however, the two have generally appeared separately. It is tempting to suggest that, if Kilroy was imported from the U.S., Chad was exported from the U.K.

According to a newspaper cutting dated 17 November 1945 quoted in Eric Partridge's *Dictionary of Slang and Unconventional English,* Chad, 'the British services counterpart of Kilroy,' was known variously as 'Flywheel, Clem, Private Snoops, the Jeep, or Phoo' (the latter particularly in Australia). Elsewhere in the *Dictionary,* Partridge says that 'Foo' was the Australian equivalent of Kilroy.

Clem' appears to have been a Canadian version of Chad or Kilroy. A story is told of an army post where all the men were told by their commanding officer that if the name Clem was inscribed anywhere again they would be severely punished. When he returned to his office, he found scrawled on the wall

"WOT, NO CLEM1?"

In Britain, one widely held view of Chad's peculiar form is that it began with an army or airforce lecture on electronics or radar. The lecturer drew on a blackboard the effect of a condenser on a circuit:

(RESISTANCE) (CONDENSER) (RESISTANCE)

He then drew a positive electrical sign on one plate, a negative one on the other, and explained that if you shorted the plates, it was equivalent to joining the two near ends of the resistors together, like this:

Some unknown hand added the single curled wisp of hair and inscribed underneath:

'WOT, NO ELECTRONS'

all of them having been discharged.

Another, similar explanation of Chad's face is that it grew out of a drawing of alternating current wave form:

The lecture is variously said to have taken place at Gainsborough, Lincolnshire, Hednesford, Staffordshire, Bolton or Blackpool. Whichever was the actual location of this great moment of popular creativity, to me it seems a feasible, if somewhat elaborate theory.

Why did the little man end up being called Chad? One correspondent who attended the Junior Technical School run from a building in Manchester Road, Bolton, suggests that service personnel attended courses at the college and the Women's Auxiliary Air Force (the WAAFs) had links with a building known as Chadwick House, which might have had something to do with the choice of name and with what the lad was looking at… A diverting piece of information comes from the same correspondent: he says the doodle became notorious after it was discovered at the scene of a serious crime and was suspected of having been scrawled there by the perpetrator.

The solution I should like to believe is that the name comes from the film *Chad Hanna,* starring Henry Fonda and Linda Darnell as a couple who run off to join the circus in mid-nineteenth-century America. I sat through the film recently in the hope that the Fonda snout would project longingly over a fence at some stage – but no, it doesn't. Even so, the film was released in Britain in June 1941 – at the very time the doodle first appeared.

H.M. Government Warning:
Sandra G****Spoils Your Health.
*on 16A London
bus*

These days govt. is a four-letter word.

Denver

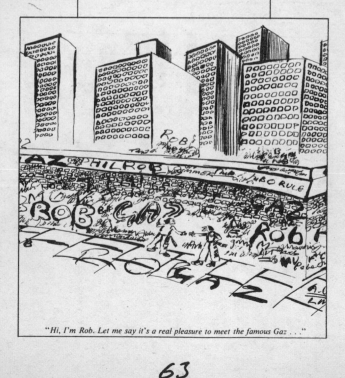

"Hi, I'm Rob. Let me say it's a real pleasure to meet the famous Gaz . . ."

Graffiti's days are numbered –
the writing is on the wall.
Colchester

what d

irish

his pet

Vaseline makes the coming easy.
And the going back.
Oxford

id the
man call
zebra?

spot!

Dunstable

HASHISH TO HASHISH, LUST TO LUST, IF THE GRASS DON'T GET·YOU, THEN ACID'S A MUST

Harrow station

Courage reaches the parts other beers don't bother with.
York

Your family's future lies in your hands.

*gents' lavatory,
traditional*

Hang the extremists.

*University of
Lancaster*

HELP THE AGED WALK
– give 'em crutches.

Leamington Spa

Hissin Sid loves Monty
Python – he's a puff adder.

*on lorry in
London*

I LOVE MARGARET
HOLMES
– Good Lord, Watson, so do I!

Liverpool

I'm so horny the crack of dawn
had better watch it!

Dover

INCEST-A
THE WHOLE
CAN PLAY

DON'T THR
IN THE TOI
THEM SOGG

W CIGARETTES

R IT MAKES

AND DIFFICULT

*T*he horses of instruction *are* greater than the tigers of wrath.*
> *Euston Square Underground station*

**B*lake, Proverbs of Hell, 'The tigers of wrath are wiser than the horses of instruction.'*

YOUNG MAN,
WELL HUNG,
WITH BEAUTIFUL
BODY IS
WILLING TO DO
ANYTHING.

P.S. IF YOU SEE THIS, BILL,
DON'T BOTHER TO CALL,
IT'S ONLY ME, TONY.

> *New York*

*C*all it incest – but I want my mummy.

> *Glasgow*

I thought that an innuendo was an Italian suppository until I discovered Smirnoff.
> *Trafalgar Square*
> *Underground station*

NO ALCOHOL IN IRAN BUT YOU CAN GET STONED ANY TIME –
and the Ayatollah Khomeini will shake you warmly by the stump.
> *London WC1*

J.R. is the Fifth Man
> *London, 1980*

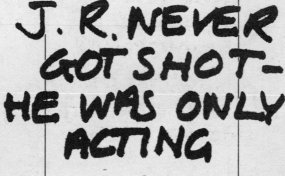

> *London, ditto.*

Johnny is only rotten. Elvis is decomposing.
> *Chelsea, 1980*

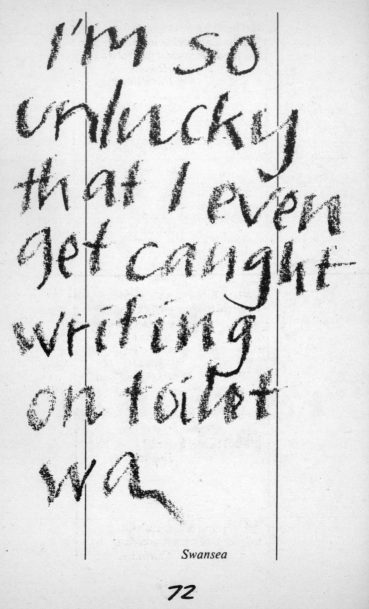

I'm so unlucky that I even get caught writing on toilet wa

Swansea

*I*f people from Hemel Hempstead get haemorrhoids, do people from Poland get Polaroids?
Hemel
Hempstead

*O*nly his hairdresser knows for sure.
New York

*G*enitals prefer blondes.
Leeds

*B*eautiful girls, walk a little slower when you walk by me.
seen by Gordon Jenkins in New York City, inspiration for 'This is all I ask'.

*W*as Handel a crank?
Taunton

*Y*our mind is like a Welsh railway – one track and dirty.
Colchester

Q. What do you call a 6'6"
Angolan guerilla with a sub-
machine gun and six hand
grenades?
A. Sir!

Piccadilly,
London

*I*f the buses were on time we
wouldn't write on bus shelters.
Bath

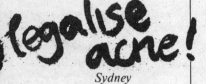

Sydney

*I*nsert baby for refund.
on contraceptive
vending machine,
Oxford

Do you realise if Kissinger was
shot today, Nixon would become
President?
Washington,
1972

Laugh, and the world laughs
with you.
Cry, and you wet your face.
Worksop

Knock softly but firmly – I like
soft firm knockers.

*on door of Ford
transit van,
Gosport*

I WILL KNOKE OFF YOUR
WIFE OR GIRLFRIEND FOR
£5. TELEPHONE WELLS *****
– by knoke do you mean 'bump'
or 'bang'?
Please answer.

*gents' lavatory of
tea-rooms, Wells*

IF I HAD THE WINGS OF A SWALLOW
AND THE ARSE OF A BLOODY
GREAT CROW
I'D FLY TO THE TOP OF THE CROWN
COURTS
AND SHIT ON OLD LASKI BELOW

*referring to
Neville J. Laski
QC, Marghanita's
father, who was
once shown this
in a Crown
Court cell*

Sausage Rolls, OK
Brighton

Kilroy was queer.
Stamford

KING KONG DIED FOR OUR SINS

New York

A KING NEVER DIES
Nottingham,
when Elvis Presley
died, amended,
when Bing Crosby
died, to
A BING NEVER DIES

Who rules the Kingdom? The King!
Who rules the King? The Duke!
Who rules the Duke? The Devil!

> *Seventeenth century, referring to George Villiers First Duke of Buckingham, favourite of King James I.*

Don't read this, you fool. Watch what you're doing.

> *gents' lavatory, Barnstaple*

GOD NIBBLES
– one does what He can.

> *Cambridge*

SAY NO TO LONDON'S THIRD AEROSOL

> *Finchley*

ALL WOMEN OVER 40 ARE
LESBAINS
– but they can spell.
Cambridge

BRIG
BOOT
– LEWES
YOUNG

Lesbians ignite!
Edinburgh

Life is biodegrable art.
London W11

Existentialism has no future.
Sydney

*T*hank God I'm an atheist.
Aberdeen

HTON
BOYS
DECENT
CHAPS.

Lewes

*L*ove makes the world go down.
Hackney

*T*his is not a dress rehearsal. This is real life.
Eight-O Club, Dallas

*L*IVERPOOL ARE MAGIC
– Everton are tragic.
Liverpool

*W*e've seen the tree Marc
Bolan hit.
Teddington

*E*lla Fitzgerald...Interesting!
Edinburgh

*J*oin the Marines – intervene in
the country of *your* choice.
Los Angeles

*L*IFT UNDER REPAIR – USE
OTHER LIFT
– this Otis regrets it's unable to lift
today.
York

*E*xamples rule, e.g.
Southport

*T*REAT OTHERS AS YOU
WOULD HAVE THEM TREAT
YOU
– I can't. I'm a masochist.
*Euston Station,
London*

Masturbation is a waste of fucking time.

Bungay

MAVIS BROWN REACHES PARTS MOST BEERS CAN'T REACH

Worksop

Since using your shampoo, my hair has come alive. Signed: Medusa.

Athens

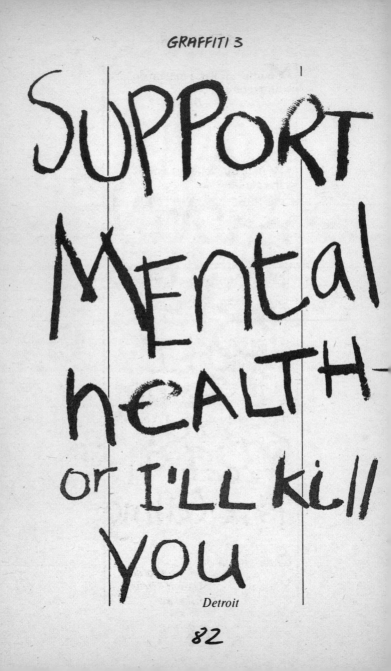

SUPPORT
Mental
hEALTH-
or I'LL kill
You

Detroit

Your face is like a million dollars
– all green and crinkly.
Denver

Where can you start a new
career at fifty?
– Become a Millwall hooligan.
Balham

Should mountain goats be
illegal?
Nottingham

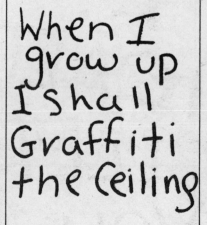

When I grow up I shall Graffiti the Ceiling

*on lavatory door,
Oxford Circus,
London*

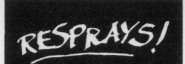

RESPRAYS!

Scribblings that have already appeared in *Graffiti Lives, OK* or *Graffiti 2,* with new variations:

*I*F TYPHOO PUT THE 'T' IN BRITAIN
– who put the 'arse' in Marseilles?

Taunton

SCOTLAND RULES OK THE NOO!

Aberdeen

*T*HE MEEK SHALL INHERIT THE EARTH
– they are too weak to refuse.

Kirkcaldy

*T*HE MEEK SHALL INHERIT
THE EARTH
– but not its mineral rights*

*a saying sometimes attributed
to J. Paul Getty

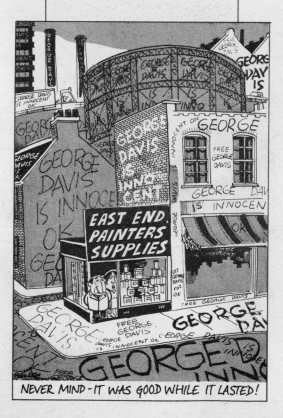

NEVER MIND – IT WAS GOOD WHILE IT LASTED!

JESUS SAVES
– Green Shield Stamps
– He's a redeemer too.
Poole

Oh do not touch me

 ,, ,, ,, ,,
 ,, ,, ,,
 ,, ,,
 ,,

 Carshalton

TOLKIEN
HOBBIT

SO IS DILDO

MADE IN THE UK
*on contraceptive
vending machine*
– so was The Titanic
– yes, but who wants to fuck
icebergs?

Letchworth

GOSSAMER LUBRICATED
contraceptive slogan
– So was the Titanic.

EINSTEIN RULES
RELATIVELY, OK
– well, in theory anyway.
London, SE6

IS

FORMING

BAGGINS!

London, W1

VICI, VENI, VD
Birmingham

BE ALERT
– your country needs lerts.
– no, Britain has got enough lerts
now, thank you. Be aloof.
– no really, be alert. There's safety
in numbers.

Hampstead

ONE WOULD THINK FROM
ALL THIS WIT
THAT SHAKESPEARE
HIMSELF CAME HERE TO
SHIT
– And this my friend may well be
true.
For Shakespeare had to do it, too.
London, EC4

WHAT ARE YOU LOOKING
UP HERE FOR? ARE YOU
ASHAMED OF IT?
– No, I'm trying to look over it.
Fort William

LIONS 7, CHRISTIANS 0
– Christians in heaven, lions ill.
Trier

WOMEN'S FAULTS ARE MANY
MEN HAVE ONLY TWO;
EVERYTHING THEY SAY
AND EVERYTHING THEY DO
– We men have many faults,
Poor women have but two:
There's nothing good they say
And nothing right they do.
Blackpool

Make your MP work – don't re-elect him.
Leicester

Mutate now and beat the rush.
Los Angeles

JOIN THE NATIONAL FRONT
– and help save Aintree racecourse.
St Helens

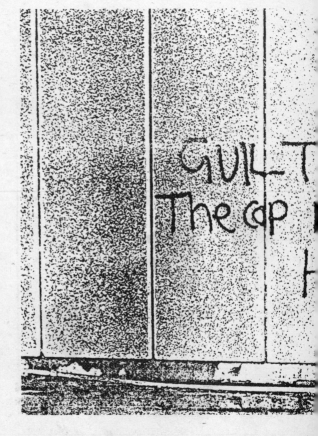

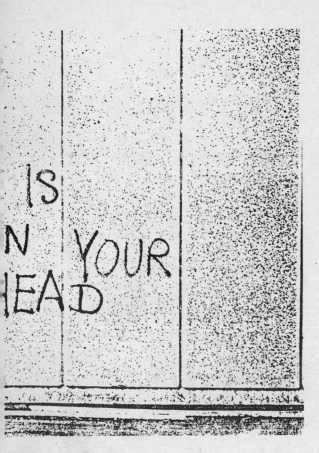

What's behind the National Front?

Hampstead

WORK–BUY–CONSUME–DIE

Wandsworth

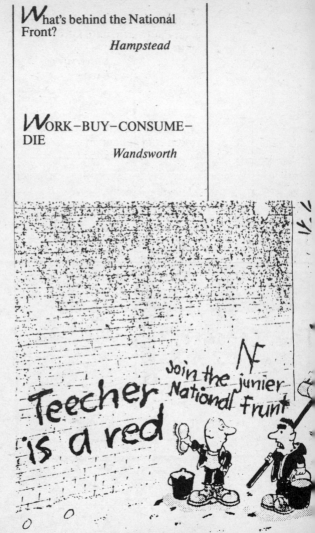

Teecher is a red

Join the junier Nationl Frunt

HE SAYS WE CAN COME BACK FROM

I thought nausea was a novel by Jean-Paul Sartre until I discovered scrumpy.

University of Exeter

I was a necrophiliac until some rotten cunt split on me.

Soho

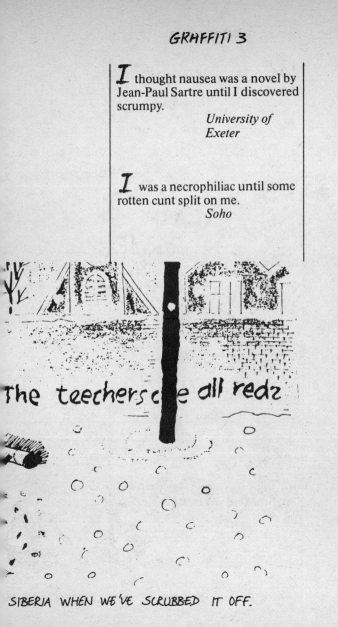

The teechers ae all redz

SIBERIA WHEN WE'VE SCRUBBED IT OFF.

LOVE THY NEIGHBOUR
– regularly.

Clapham

Does the
Netherlands
Royal Family
suffer from
Dutch Realm
Disease?

Amsterdam

1978 makes 1984 look like 1967.

Clerkenwell

Forget the notes and play the music.

Edinburgh

Nothing Beats the great Smell of Brut

— then why not use nothing?

Soho

Nottingham Forest wipes the floor with Ajax.

Nottingham, 1980

Nudists are people who wear one-button suits.

Sheffield

Women should be obscene and not heard.

Hertford

Oedipus was the first man to bridge the generation gap.

*New College,
Oxford*

Open this end, Paddy.

*with a large arrow
pointing to the
rear of an Irish
articulated lorry*

Support wild life – vote for an orgy.

Oxford

Orville was also Wright.

Bristol

Please pass – driver on overtime.

in dust on lorry

Hands off Cubal.

*a popularl
graffitol from
Bristol*

STOP PASSENGER AS YOU
PASS BY
AS YOU ARE NOW SO ONCE
WAS I.
AS I AM NOW SO YOU WILL
BE
SO BE PREPARED TO
FOLLOW ME.

*gravestone at
Anworth,
Gatehouse of Fleet*

– To follow you I'd be content
If I only knew which way you
went.

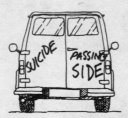

*in dust on back
of van*

Patrons are requested to remain
seated throughout the
performance.

gents' lavatory,
Leominster

MEN WH

PUT WO

PEDEST

RARELY

THEM C

I used to dress off the peg, but now the neighbours take their washing in at night.

Irvine, Ayrshire

*N*o matter how you shake your peg. The last wee drop runs down your leg.

traditional

*ladies' lavatory,
Charing Cross*

You don't come here to sport
and play
But when you've done go straight
away.

gents' lavatory,
Crewe

JESUS LOVES
BLACK AND WHITE
(but he prefers Johnny
Walker!)

Bath

The penis is mightier than the
sword.

Cambridge

La différence entre les sexes
n'existe pas.
Les femmes pètent aussi.

Caen

ST PETER'S SQUARE
– I know he is.

London W6

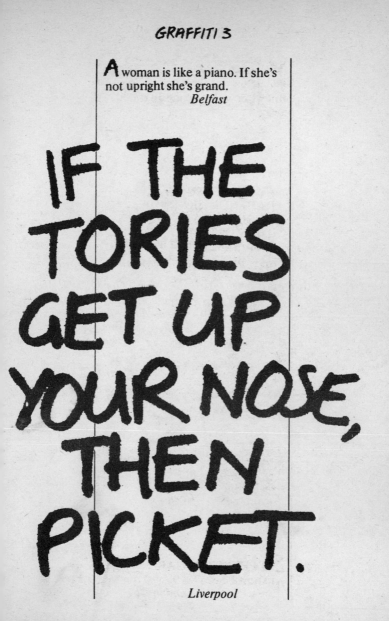

A woman is like a piano. If she's
not upright she's grand.
 Belfast

IF THE
TORIES
GET UP
YOUR NOSE,
THEN
PICKET.

Liverpool

Paris

NEITHER SNOW NOR
RAIN NOR HEAT NOR
GLOOM OF NIGHT STAYS
THE COURIERS FROM THE
SWIFT COMPLETION OF
THEIR APPOINTED
ROUNDS

> *inscription from
> Herodotus on
> General Post
> Office, New York*

– well, what is it then?

Power corrupts – absolute
power is even more fun.
> *Brighton*

I'm not prejudiced – I hate
everyone.
> *Surbiton*

Old professors never die –
they simply lose their faculties.
> *Norwich*

*L*ife is like a pubic hair on a toilet seat – eventually you get pissed off.

Oxford

*D*rivers – don't pull out to avoid a child – you could fall off the bed.

M1 motorway cafe

*P*UNK IS DEAD
– no, it just smells that way.

Earls Court

*T*he guy at the front is the driver, not Quasimodo, so only ring the bell once.

London No. 29 bus

QUASIMODO
-THAT NAME
RINGS A BELL

Middleton St George

Q. What is the difference between a Radox bath and Louis Frémaux?
A. Radox bucks up the feet.

Birmingham

Soyez raisonnable, demandez l'impossible.

Cambridge, 1969

GIRLS, DO
DRIVE ME
ALIENATI
YOURSELV
REVOLU

*D*ISARM ALL RAPISTS
– it's not their arms I'm
worrying about.

Newmarket

I AM NOT AN ANIMAL!
I AM A HUMAN BEING!

poster for film
The Elephant
Man, *Turnham
Green
Underground
station*

– I am Ronald Reagan!

N'T
NTO
ON! OFFER
S TO THE
TION!

Paris 1968

WHEN THE REVOLUTION COMES WE'LL ALL DRIVE ROLLS ROYCES
– what if we don't want to drive Rolls Royces?
– when the Revolution comes you won't have any choice.
Hemel Hempstead

'You DON'T NEED A WEATHERMAN
To KNOW WHICH WAY THE WIND BLOWS'
— B. DYLAN

MARX LIVES!

FREEDOM FOR THE LOWER CLASSES!

REVOLUTION NOW!

KILL ENGELS

SMASH CAPITALISM!

KILL THE PIGS!

FASCISM!

WORKERS UNITE

KILL

REVOLUTION!

DESTROY THE MIDDLE-CLASS!

"DO YOU REALISE THAT IT'S TEN YEARS TO THE DAY SINCE WE WROTE ALL THAT?"

*T*oilet paper supplied by the Master of the Rolls.

> *Law Courts,*
> *The Strand,*
> *London*

*L*IBERTÉ – ÉGALITÉ – FRATERNITÉ
– Maternité.

> *Hospital, Paris*

*I*N CASE OF FIRE DO NOT ATTEMPT TO USE THE LIFTS
– try a fire extinguisher.

> *lift, University*
> *College, Cardiff*

It's 12" long but I don't use it as a rule

> *Berkhamsted*

*G*ive sadists a fair crack of the whip.

> *Crawley*

SAME THING
-TUBE, WORK
TUBE, ARMCH
TUBE, WORK -
MORE CAN
ONE IN FIVE
ONE IN TEN

DAY AFTER DAY,
DINNER. WORK
AIR, T.V. SLEEP,
HOW MUCH
YOU TAKE?
CRACKS UP.
GOES MAD.

*Swiss Cottage
Underground station*

*T*hanks be to God for finally proving the non-existence of Jean-Paul Sartre.

*King's College,
London, 1980*

*T*he S.A.S. smoke more Embassies than Hurricane Higgins.

Dunstable, 1980

*S*ave fuel – burn an Arab.
on back of lorry

*S*ex appeal – please give generously.

Aston Clinton

*I*f sex is a pain in the arse – you're doing it wrong.

Nottingham

*S*ex kills – die happy.
Orpington

More than three shakes is masturbation.

*gents' lavatory,
Glasgow*

Shetland Ponies Have Earlobes.
Vancouver, B.C.

NO SIGNALS
EX NO.14
BUS
DRIVER

on lorry on M2

*B*ring back the Sixties.
California, 1980

*S*KINHEADS ARE BASTED
– yes, indeed, they frequently are,
but wrapped in foil and slowly
roasted with just a hint of
marjoram in their own juices –
ah, what piquancy!
Essex Road
British Rail
station, London

*S*kinheads have more hair than
brains.
Charing Cross
Underground
station

*T*he trouble with political jokes
is they get elected.
Wolverhampton

I asked the manager for a suite
with a view – he gave me a Polo
mint.
YMCA, London

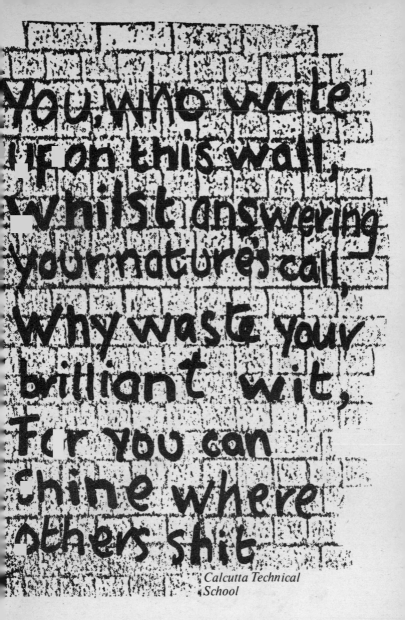

You, who write
[] on this wall,
whilst answering
your nature's call,
Why waste your
brilliant wit,
For you can
shine where
others shit

Calcutta Technical
School

113

*E*NGLISHMEN MAKE THE
BEST LOVERS
– the Japanese make them
smaller and cheaper.
London SW1

GUYF

WHEREA

NOW T

NEED

*W*orking for the *******Bank is like smoking dope – the more you suck, the higher you get.
Holborn

AWKES
RE YOU
HAT WE
YOU ?

in dust on back of lorry

In the United States, where even today the writing of a graffiti-artist's name is often more prevalent than any views he may have to express, there used to be a name to rank with those of Kilroy and Chad. William and Mary Morris in their *Dictionary of Word and Phrase Origins* recall that the name 'J B King' appeared on just about every piece of railroad rolling stock west of the Mississippi in the early part of this century. The name appeared in elegant script, omitting the full stops after the J and B, and all the letters were made with a single stroke of the chalk or crayon.

The Morrises received a letter not from any Mr J. B. King but from a Mr J. A. Abbott of St Joseph, Missouri, who claimed to have been the first to write this legend on freight wagons when he went to work for the railways in Atchison, Kansas. He said he took the signature from a handwriting manual. 'I went to work for the St Joseph and Grand Island (railroad) and, during World War I, put "J B King" on every piece of war machinery I could reach…recently [I] ran across a car on which I had written "J B King Esq 12.8.1914." It was pretty dim but could not be read, so I just put another right over it'.

Unfortunately the Morrises seem to have passed up the opportunity of asking Mr Abbott (if indeed he was the perpetrator) why on earth he did it.

Dr Strangelove – or how I learned to stop worrying and love the bum.

Chelsea

Stranger, stop and wish me well,
Just say a prayer for my soul in Hell.
I was a good fellow, most people said,
Betrayed by a woman all dressed in red.

*chalked on alley
wall outside the
Biograph Theatre,
Chicago, just
after John
Dillinger, the
gangster, was
shot dead there,
1934*

FEEL SUPERIOR-
BECOME A NUN!

*New College,
Oxford, 1966*

Elsie Tanner threw me out.
*on back of lorry
on M1*

Half the girls at this college have TB, the other half have VD – so sleep with the ones who cough.

University of
Durham

Keep your distance – sudden tea-breaks.

on back of Gas
van seen in
Leominster

DESTROY THATCHER
– not you, Sid.

on wall in
picturesque
Dorset village

Just think – maybe the Joneses are trying to keep up with you.

Carshalton

Q. What do you get when you cross a vagina with a silicon chip?

A. A cunt that knows everything.

London W1

Support British Steel – smelt the Iron Lady.

Dumbarton, 1980

What's stiff and excites women? Elvis Presley.

Nottingham

Stop the world I want to get off.
appeared as a graffito before being used as the title of a musical

BEWARE RETREADS

on contraceptive vending machine, Cardiff

What is the difference between
God and Professor ********?
God is here but everywhere.
Professor ******* is everywhere
but here.

> *University of*
> *East Anglia*

Roses are red,
Pansies are gay,
If it weren't for kind ladies,
We'd all be that way.

> *Eastbourne*

This wall has now been reopened.

> *chiselled on wall*
> *newly*
> *pebbledashed*
> *to prevent graffiti-*
> *writing*

WEARING THESE IS LIKE
PICKING YOUR NOSE WITH
RUBBER GLOVES ON

> *on contraceptive*
> *vending machine,*
> *Macclesfield*

– My God, what a nose you've got!

GRAFFITI 3

WATCH THIS
SPACE
—why whats
it doing?

Hertford

*I*f you are not part of the solution
then you are part of the problem.
Oxford

SODOM IS A SUMMER
FESTIVAL
– Gomorrah the merrier.
New York

IF YOU sprir
tinkle.B
wipe the

Hurrah, hurrah, it's Spring,
The boid is on the wing.
How utterly absoid!
The wing is on the boid.

New York

kle when you

e a sweetie,

seatie

*ladies' lavatory,
Totnes*

Pity the man with ambition so small He writes his name on a lavatory wall.

London EC3

Apathy rules, oh dear…
Bristol

Before the Thatcher
Government came to power we
were on the edge of an economic
precipice – since then we have
taken a great step forward.
Polytechnic of the
South Bank,
London

Do not disturb, seeds planted.
in dust on a very
dirty car,
traditional

Nuclear power plants are built
better than Jane Fonda.
Philadelphia,
1980

Wiggle your toes for sex.
gents' lavatory,
Philadelphia

The only good Tory is a lavatory.
Blackpool

THIS IS THE AGE OF THE TRAIN
– it takes an age to catch one.
Paddington Station, London

THE LAST
TRAIN RUNS
LATER
THAN YOU THINK
— why pick on
that one?

Charing Cross Underground station

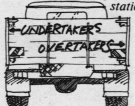

UNDERTAKERS
OVERTAKERS

in dust on back of lorry

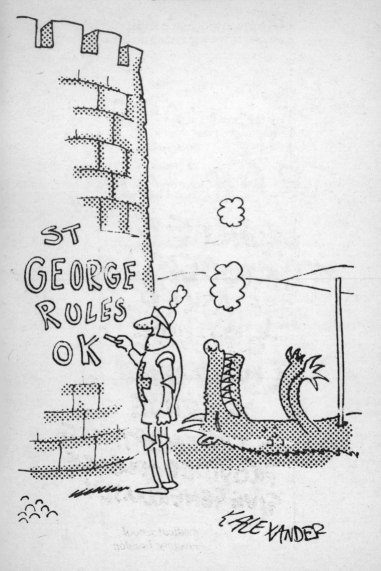

*U*nilateral withdrawal is the
answer to the population problem
Barnstaple

All this beer drinking will be the
urination of me.
Stamford

MEDICAL
STUDENTS
ARE ASKED
TO PROVIDE
A SPECIMEN
OF URINE
IN THE RECEPTACLE
PROVIDED - PLEASE
GIVE GENEROUSLY

*medical school
lavatory, London*

127

Visit the USSR before the USSR
visits you.

London W1

VD is nothing to clap about.
ladies' lavatory,
Alaska

RES
A PAIN
NECK

Scunthorpe

WHEN TWO N
A RAILWAY C
MAN EXPOSEI
FAINTED AND
HAD A STRO

There is no fury like a vested interest masquerading as a moral principle.

Hampstead

Help your local police cut out graffiti. Carry a saw.

*Glen Prosen,
Scotland*

UNS WERE IN
ARRIAGE, A
HIMSELF. ONE
THE OTHER
KE

Southampton

I don't pee in your swimming
pool. So please do not swim in
my loo.

gents' lavatory,
Sunningdale

I wish I could drink like a lady
I can take one or two at the most.
Three puts me under the table
And four puts me under the host.
Letchworth

*T*his shall be the Rosetta Stone for the next civilisation, consider your words well.
New York

IN CAS
MALFUN
MAR

*D*rinking ******'s beer is like making love in a boat – it's fucking close to water.
Birmingham

*I*f you have wet dreams, take your umbrella to bed with you.
Stockport

on contraceptive
vending machine,
West Germany

*T*ypical workman. He promises
to plane my door today but he's
gadding off to Jerusalem on a
donkey.

Worksop

*B*ureaucracy rules OK
 OK
 OK
Swansea

*S*ave a whale – shoot a Nip.
Batley

I whisper your weight.
on weighing machine, Dartford

HYGEINE

Please Now
Burn Your
Clothes

W.H
F.C.

*H*ave wife, must travel.

on back of lorry

*W*e the willing, led by the unknowing, are doing the impossible for the ungrateful. We have done so much for so long with so little, we are now qualified to do anything with nothing.

Ninth Precinct police station, New York

WOMEN'S BODIES BELONG
TO THEMSELVES
– I do so agree – but isn't it nice to
share?

ladies' lavatory,
London WC1

Women's libbers should be put
behind bras.

University of
Adelaide

(disc-on-tent)

(H8 = Hate)

visual graffiti
common among
service men,
early 1960s

THIS WALL IS ALSO
AVAILABLE ON CASSETTE
AND CARTRIDGE IN MOST
GOOD RECORD SHOPS

Sowerby Bridge

TO BE A TRIX OR NOT
TO BE A TRIX THAT IS THE
QUESTION

Groningen,
Netherlands, 1980

NEXT TIME LEAVE THE
CAR AT HOME

> *poster for London*
> *Underground*
> *showing wife and*
> *daughter finding*
> *Tube train in*
> *garage*

– another of his practical jokes.

If girls are made of sugar
and spice, How come they taste
like tuna fish?

Seattle

DON'T LET TURKEY
BECOME ANOTHER CHILE
– make a risotto.

Oxford

Two's company, three's a
deformity.

London W1

Dog with no legs called
Woodbine. His master took him
out for a drag

Bradford

Q. What's white and slithers across the floor?

A. Come Dancing.
Manchester

FREE SID VICIOUS
– well, I certainly wouldn't pay for him.

Waterloo Station,
London

Who's afraid of Virginia Wade?
Wimbledon
Station

Who's afraid of Virginia Woolf?
found by Edward
Albee on a
lavatory wall and
used by him as
the title of play

THE WAGES OF SIN
IS DEATH
BUT THE HOURS
ARE GOOD
Sheffield

*E*NGLISH CAPITALISTS
OUT!
WALES HAS BEEN SOLD!
– Subject to contract.
North Wales

SUPPOSING THEY GAVE
A WAR- AND NOBODY CAME
*New Orleans,
1972*

FIGHT FOR THE
RIGHT TO PRETEND
TO WORK
Marylebone

YOU ARE ADVISED
TO WASH YOUR
HANDS AFTER USING
THIS TOWEL
*on dirty roller
towel, Leicester*

WURLITZER ONE FOR THE MONEY TWO FOR
THE SHOW. *Worksop*

*W*ATERSHIP DOWN
– you've read the book, you've
seen the film, now eat the pie!
London EC1

*E*IGHT OUT OF TEN
EXECUTIVES WALK THIS
WAY
*Yellow Pages
advertisement*
– they should loosen their braces.

I hate Yorkies and I hardly ever smile.

*on back of lorry,
seen in Hendon*

*F*EWER DOGS, CLEANER STREETS
– fewer graffiti, cleaner walls.
Canterbury

*P*eople don't die in Eastbourne, they just stand them at bus stops.
Eastbourne

*I*n the stronghold of woman I plan an uprising.
Bury St Edmunds

Q Why do people write 'Fuck the Pope' on toilet walls?
A. Because they can't be bothered to write 'Fuck the Moderator of the General Assembly of the Church of Scotland.
Edinburgh

*Y*ou could go through Governor Reagan's deepest thoughts and not get your ankles wet.
Los Angeles, 1980

KEEP YOUR NUTS WARM — NICE ONE SQUIRREL

Worksop

CLOSE ENCOUNTERS
OF THE THIRD KIND
SPECIAL EDITION
NOW THERE IS MORE
DIRECTOR STEVEN
SPIELBERG HAS FILMED
ADDITIONAL SCENES,
DESIGNED TO EXPAND AND
ENHANCE THE ORIGINAL
FILM
– and we still can't understand it!

*Turnham Green
Underground
station*

If you believe in God, you are
welcome to pray;
If you do not believe in God, you
are welcome to visit;
If you are vain and callous about
the rights and feelings
Of others, write your name on our
walls.

*notice at entrance
to Franciscan
church, Mount
Tabor, Israel*

Remember – graffiti doesn't
grow on walls.

Barking

Some day my prince will come.
However, I'll have nothing to do
with it.

*ladies' lavatory,
Amherst, Mass.*

Q WHAT DO YOU CALL A
FISH WITH 2 KNEES?
A. A TWONY FISH.

Edinburgh

The Communist Party of Great
Britain (Marxist-Leninist) wishes
to apologise for the late arrival
of the 1979 workers' revolution.

*Bristol
Polytechnic*

Normal service will be
exhumed as soon as possible.

*during
gravediggers'
strike, 1979*

If Nigel Rees is reading this, I
hope I get paid this time.

*Cambridge
Circus,
London*

I only wrote this to get on
'Quote…Unquote'.

British Museum

I WONDER, O WALL
THAT YOU HAVE NOT
COLLAPSED UNDER ALL
THE WEIGHT OF ALL THE
IDIOCIES WITH WHICH
THESE IMBECILES COVER
YOU .

Pompeii

Acknowledgements

This book, like its predecessors, would not have been possible without the flair of countless graffiti-writers all over the world. My thanks to them, whoever they are, wherever they are.

I am also indebted to a large number of correspondents who have enthusiastically shared with me the graffiti they have encountered, or have contributed information and opinions on the practice of graffiti-writing. They include (to mention but a few): Allan Robinson, Polegate; Stewart Gellatly, Edinburgh; Revd C. F. Warren, Machen, Newport; Eileen Pincock, Torquay; David Pritchard, Worksop; Capt. A. P. Mason, Northfield, Birmingham; Bruce Irving, Worsley, Manchester; W. G. Davies, Pontypridd; Colin G. White, Macclesfield; Richard

Sheppard, Norwich; Sue Jamieson, Aberdeen; W. J. Watt, Southport; Joanna Reddick, Stockport; Dr C. B. Lucas, Egham; Phil Horwood, Hextable; Dr Bernard A. Juby, Yardley; A. A. Morley; Margaret Thomas, Clapham; Ray Dudley, Walthamstow; Graeme Ashford; Philip Gaskell, Cambridge; K. P. G. North, Cambridge; Les Killip, Camberley; Anon. Christchurch; Mrs Claire Hawthorn; C. F. Flesch, Highgate; Suresh Narayan Amirapu, Singapore; Mat Coward, Hampstead; R. D. Harris, London SE6; Hilary Fenten, London SW6; G. S. Middlemiss, Oxford; A. Charge, Solihull; Ena Smith, Eastbourne; Dr A. B. Lavelle, Bristol; K. D. Scott, Northampton; Stephen Morant, Harrogate; E. Riley, East Meon; Mrs W. Clay, London E3; P. Sharpe, Brighton; Nina Sansome, Pinner; Max L. Fincke, Cromer, N.S.W.; Tim Denes, Mosman, N.S.W.; Tim Duncan, Barry; Bernard Meares, London NW3; Thomas Murphy, London SW17; plus toilers in related fields: Celia Haddon; Keith Parry; Barry Day; Terence Kelly; Keith Ravenscroft; Chris Atkinson; Dr Brian A. Richards; and the member of the Shadow Cabinet with a sense of humour.
I am grateful, too, to the authors and publishers of the following books which have supplied relevant information:
Martin Page, *For Gawd's Sake Don't Take Me* (Granada); Stuart Berg Flexner, *I Hear America Talking* (Simon & Schuster); Eric Partridge, *A Dictionary of Slang and Unconventional English* (Routledge & Kegan Paul);
William and Mary Morris, *The Morris Dictionary of Word and Phrase Origins* (Harper & Row);
William Safire, *Safire's Political Dictionary* (Random House)